MYTH AND ROMANCE
THE ART OF J W WATERHOUSE

OPHELIA
DETAIL

'I AM HALF-SICK OF SHADOWS,'
SAID THE LADY OF SHALOTT
OVERLEAF

PENELOPE AND THE SUITORS
DETAIL OVERLEAF

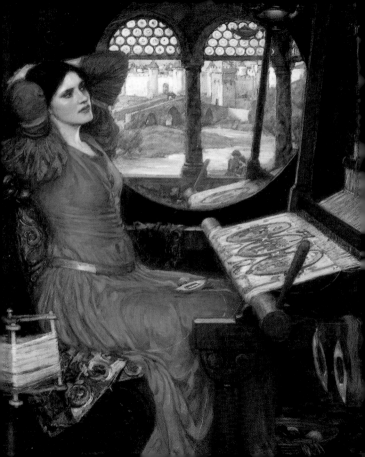

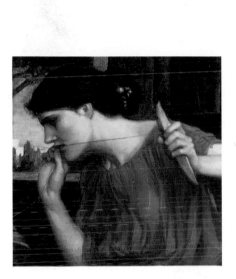

MYTH AND ROMANCE
THE ART OF J W WATERHOUSE

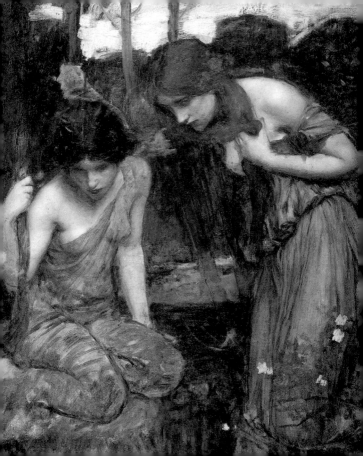

John William Waterhouse was born in Rome in 1849. This early baptism in Italy's classical heritage was to have a profound effect on his life's work, immersing his art in ancient myth and literary allegory. Throughout his schooldays, Waterhouse's artistic talent lay dormant, but his young mind was constantly nourished on a diet of ancient history which he read voraciously. It was while working as an apprentice in his father's art studio that the boy's ability as a painter emerged and he gained entrance as a scholar into the Royal Academy. Throughout his career he won acclaim as a masterful story-teller, with an instinctive gift for suspending the viewer at the most striking moment of the narrative. His numerous paintings of historical, mythical and literary episodes embroider the original tales with imagery from his own fertile imagination Waterhouse's most productive years were spent at his Primrose Hill Studios in London, where he populated his canvases with haunting compositions of young, waif-like models. He continued to paint until his death in 1917, leaving a rich legacy of archetypal Victorian images – particularly of wistful female beauties.

STUDY FOR NYMPHS FINDING
THE HEAD OF ORPHEUS

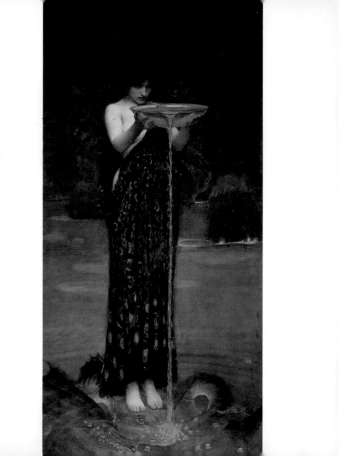

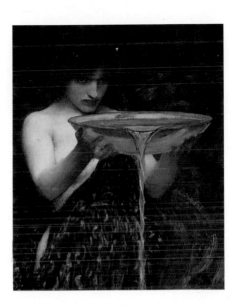

CIRCE INVIDIOSA

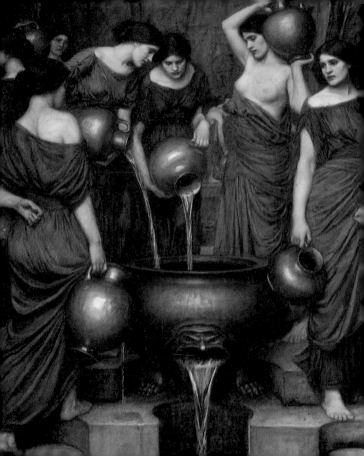

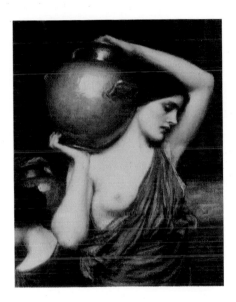

DANAÏDES
DETAIL

THE DANAÏDES

DANAÏDES

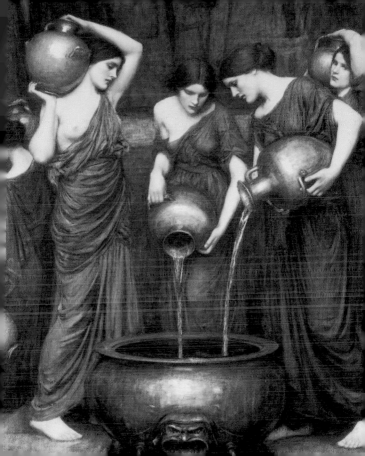

If by your art, my dearest father, you have
Put the wild waters in this roar, allay them:
The sky, it seems, would pour down stinking pitch,
But that the sea, mounting to the welkin's cheek,
Dashes the fire out. O! I have suffer'd
With those that I saw suffer: a brave vessel
Who had, no doubt, some noble creatures in her,
Dash'd all to pieces. O! the cry did knock
Against my very heart.

The Tempest Act I, Scene ii
(William Shakespeare 1564-1616)

MIRANDA – THE TEMPEST
DETAIL AND OVERLEAF

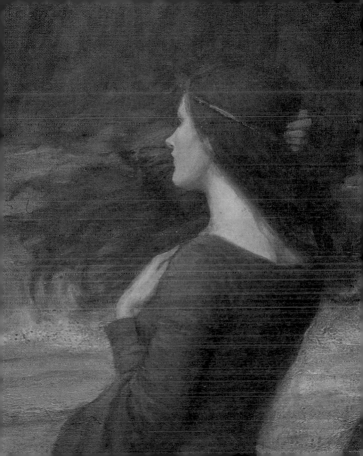

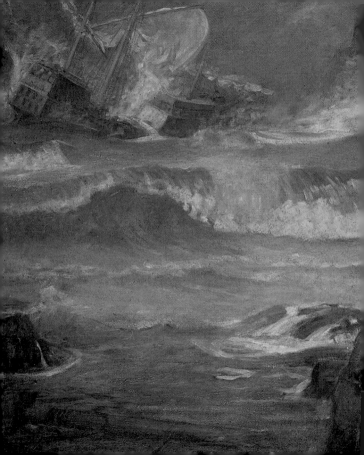

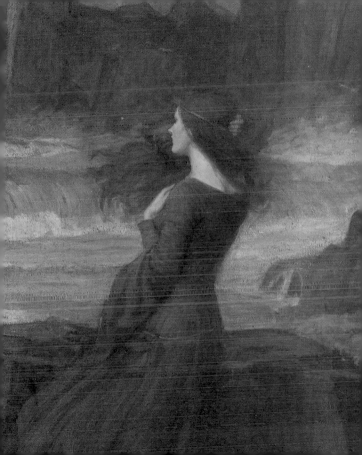

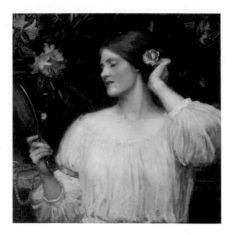

VANITY

OPHELIA

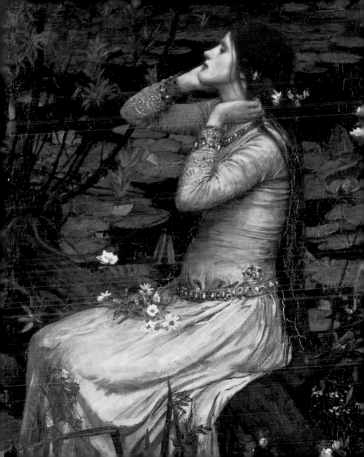

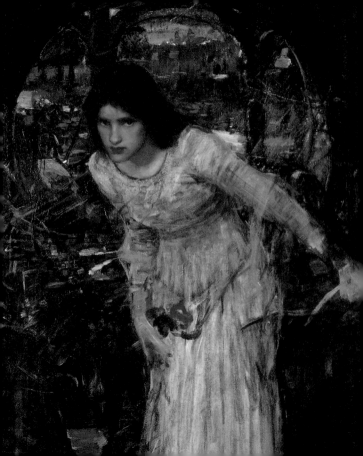

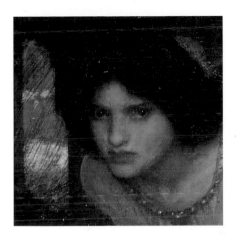

THE LADY OF SHALOTT
DETAIL

STUDY FOR THE LADY OF SHALOTT

She left the web, she left the loom,
She made three paces through the room,
She saw the water-lily bloom,
She saw the helmet and the plume,
 She looked down to Camelot.
Out flew the web and floated wide;
The mirror cracked from side to side;
'The curse is come upon me,' cried
 The Lady of Shalott.

The Lady of Shalott
(Alfred, Lord Tennyson 1809-92)

THE LADY OF SHALOTT

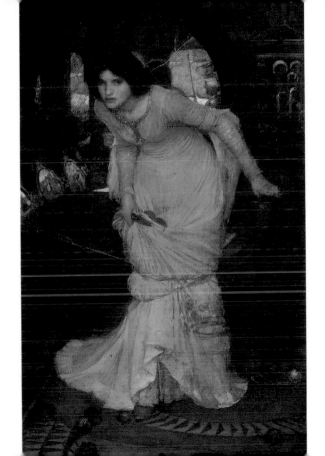

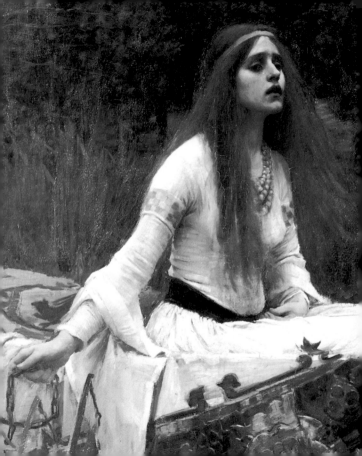

And down the river's dim expanse
Like some bold seër in a trance,
Seeing all his own mischance–
With a glassy countenance
 Did she look to Camelot.
And at the closing of the day
She loosed the chain, and down she lay;
The broad stream bore her far away,
 The Lady of Shalott.

The Lady of Shalott
(Alfred, Lord Tennyson 1809–92)

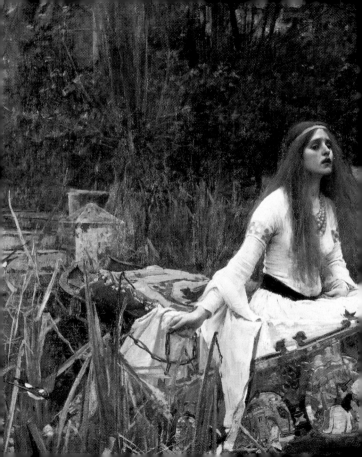

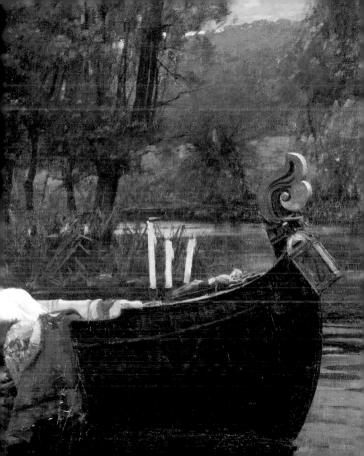

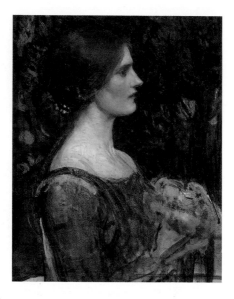

THE BOUQUET

PORTRAIT OF A LADY
IN A GREEN DRESS

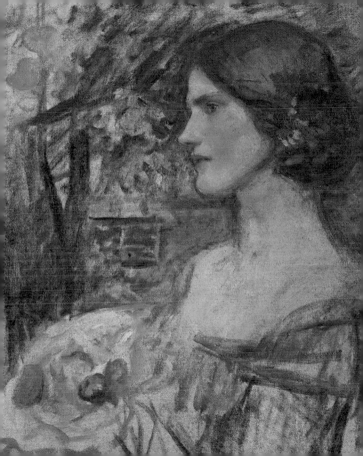

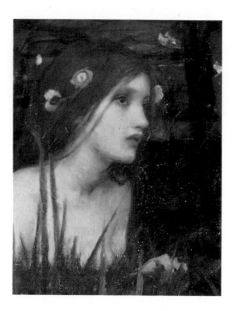

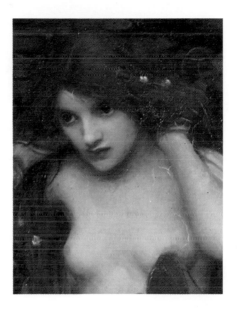

HYLAS AND THE NYMPHS
DETAILS

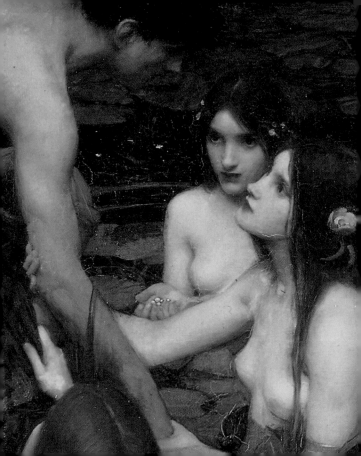

The wanton Maidens him espying, stood
　　Gazing a while at his unwonted guise;
　　Then th'one her selfe low ducked in the flood,
　　Abasht, that her a straunger did avise:
　　But th'other rather higher did arise,
　　And her two lilly paps aloft displayd,
　　And all, that might his melting hart entise
　　To her delights, she unto him bewrayd:
The rest hid underneath, him more desirous made.

The Faerie Queene
(Edmund Spenser 1552? 99)

HYLAS AND THE NYMPHS
DETAIL AND OVERLEAF

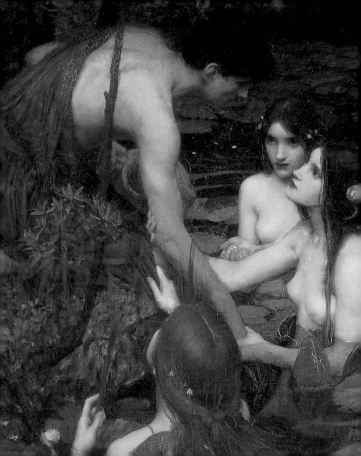

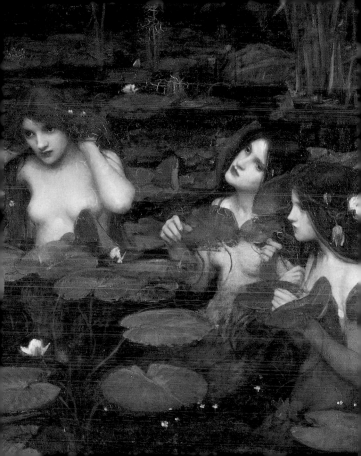

STUDY: THE NECKLACE
DETAIL

—

A HAMADRYAD

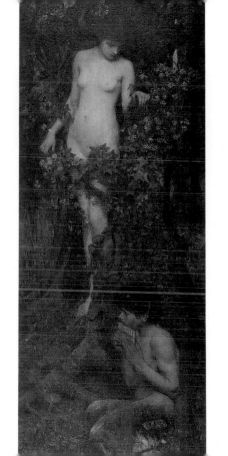

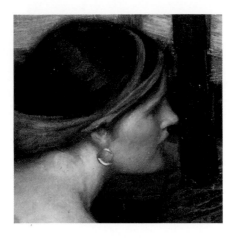

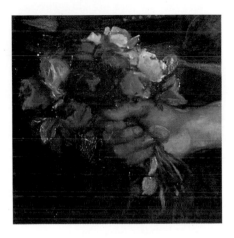

PENELOPE AND THE SUITORS
DETAILS AND OVERLEAF

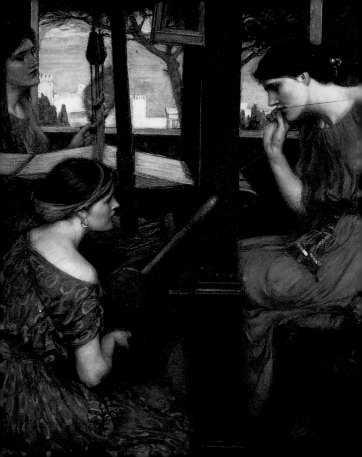

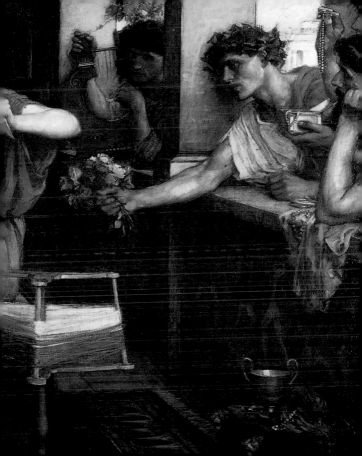

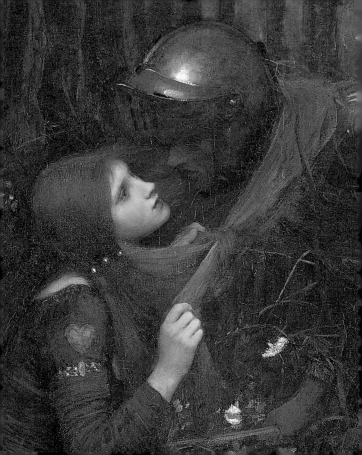

'I met a lady in the meads,
 Full beautiful, a faery's child;
Her hair was long, her foot was light,
 And her eyes were wild.

'I made a garland for her head,
 And bracelets too, and fragrant zone;
She looked at me as she did love,
 And made sweet moan.'

<div align="right">La Belle Dame Sans Merci
(John Keats 1795-1821)</div>

LA BELLE DAME SANS MERCI
DETAIL

And I, of ladies most deject and wretched,
That suck'd the honey of his music vows,
Now see that noble and most sovereign reason,
Like sweet bells jangled out of tune and harsh,
That unmatch'd form and feature of blown youth
Blasted with ecstasy. O, woe is me
T'have seen what I have seen, see what I see.

Hamlet Act III, Scene i
(William Shakespeare 1564-1616)

OPHELIA
DETAIL

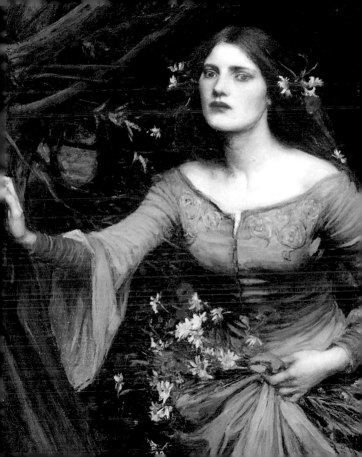

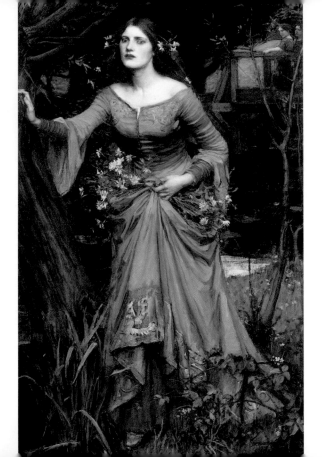

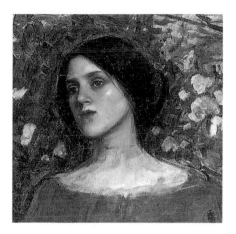

THE ROSE BOWER

OPHELIA

THE AWAKENING OF ADONIS
DETAIL AND OVERLEAF

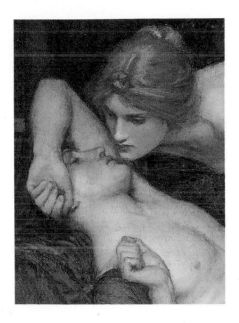

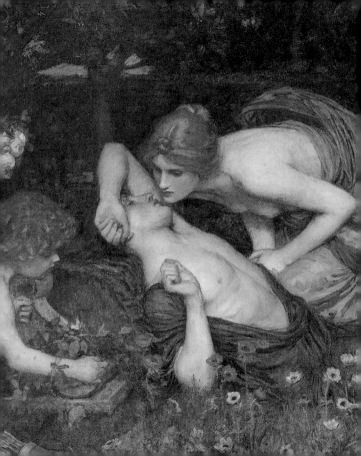

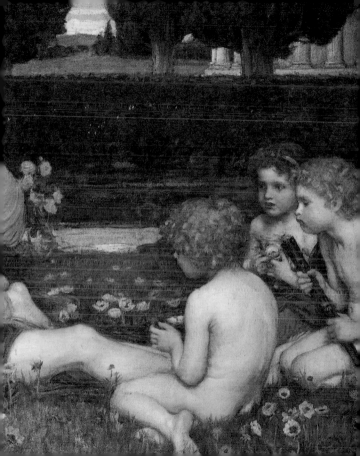

A rosy sanctuary will I dress
With the wreathed trellis of a working brain,
 With buds, and bells, and stars without a name,
With all the gardener Fancy e'er could feign,
 Who, breeding flowers, will never breed the same;
And there shall be for thee all soft delight
 That shadowy thought can win,
A bright torch, and a casement ope at night,
 To let the warm Love in!

Ode to Psyche
(John Keats 1795-1821)

PSYCHE ENTERING
CUPID'S GARDEN

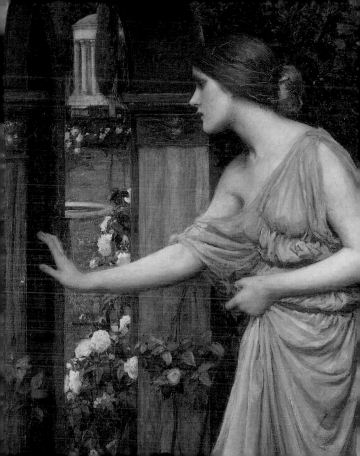

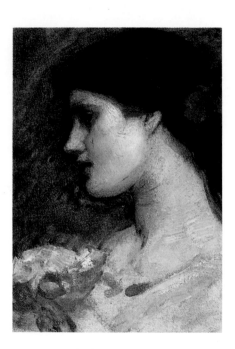

CAMELLIAS

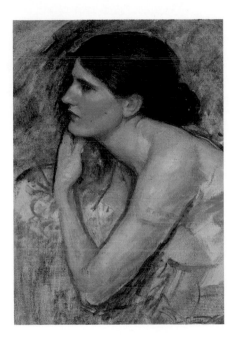

STUDY FOR THE SORCERESS

THE SORCERESS
OVERLEAF

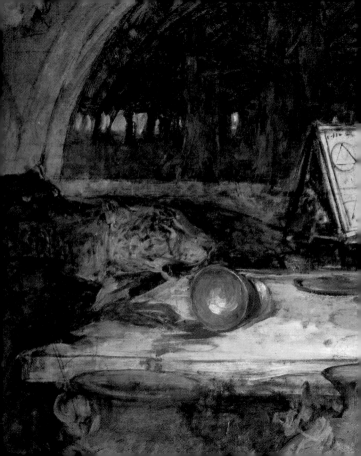

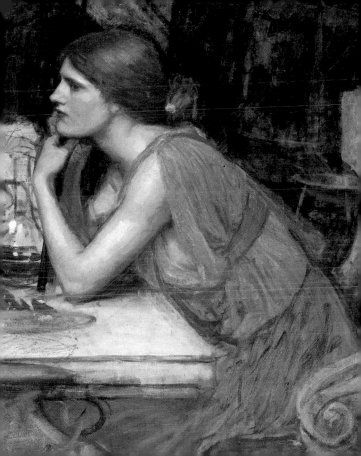

ARIADNE
DETAILS

Whan Adryane his wif aslepe was,
For that hire syster fayrer was than she,
He taketh hire in his hond and forth goth he
To shipe, and as a traytour stal his wey,
Whil that this Adryane aslepe lay,

The Legend of Good Women
(Geoffrey Chaucer c1343-1400)

ARIADNE
DETAIL AND OVERLEAF

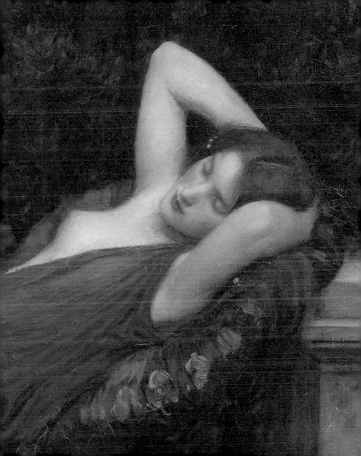

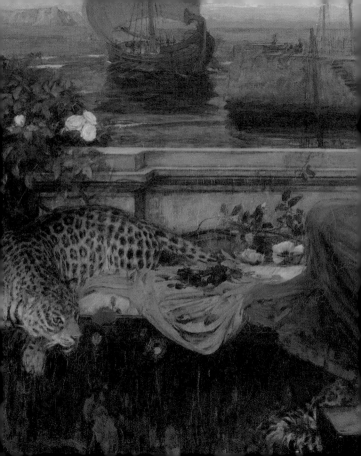

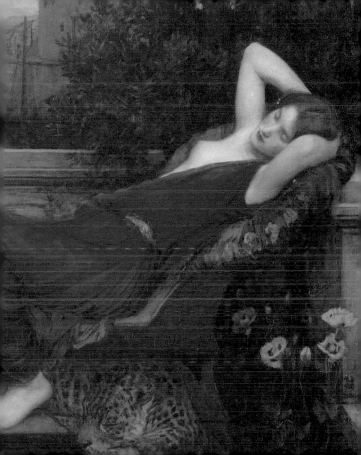

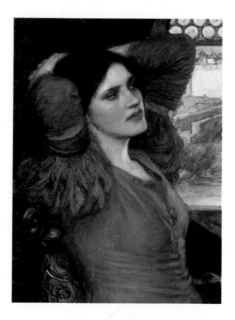

'I AM HALF-SICK OF SHADOWS,'
SAID THE LADY OF SHALOTT
DETAIL

DESTINY

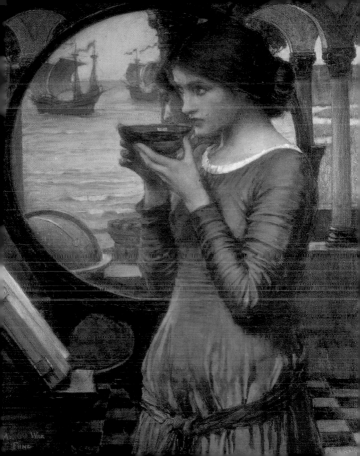

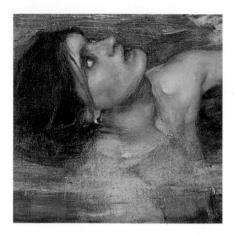

THE SIREN
DETAILS

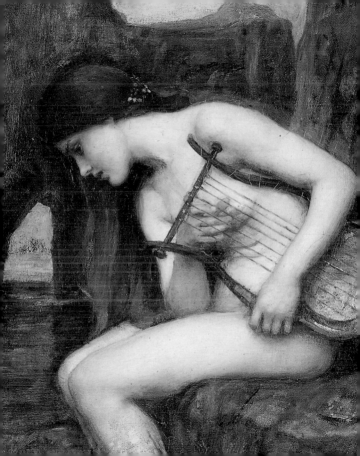

The sea-nymphs chant their accents shrill;
 And the Sirens, taught to kill
 With their sweet voice,
Make every echoing rock reply,
Unto their gentle murmuring noise,

In Praise of Neptune
(Thomas Campion 1567-1620)

THE SIREN
———
ST CECILIA
OVERLEAF

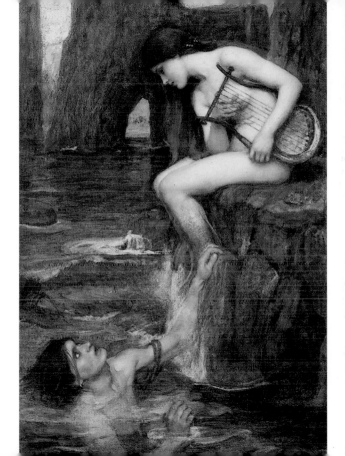

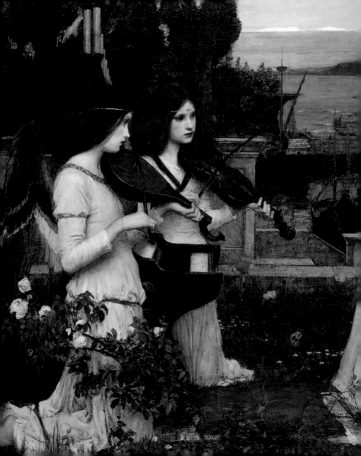

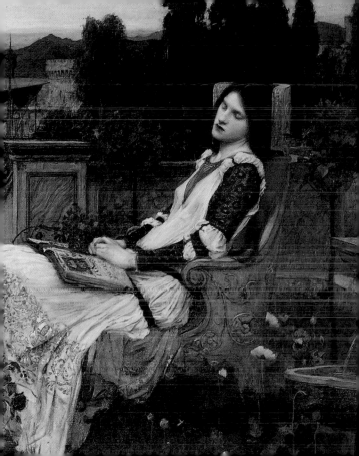

ULYSSES AND THE SIRENS
DETAILS

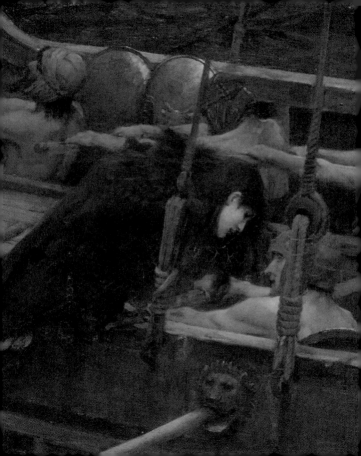

Steer, hither steer your wingèd pines,
 All beaten mariners!
Here lie Love's undiscovered mines,
 A prey to passengers;
Perfumes far sweeter than the best
Which make the Phoenix' urn and nest.
 Fear not your ships,
Nor any to oppose you save our lips;
 But come on shore,
Where no joy dies till Love hath gotten more.

<div align="right">

The Sirens' Song
(William Browne of Tavistock 1591-1643)

</div>

ULYSSES AND THE SIRENS
DETAIL AND OVERLEAF

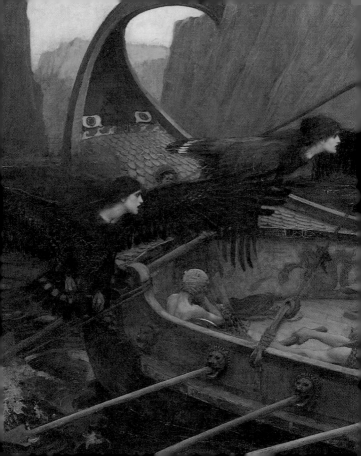

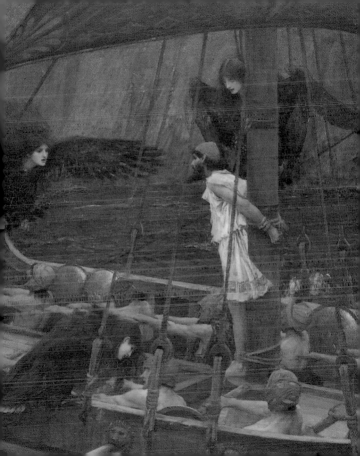

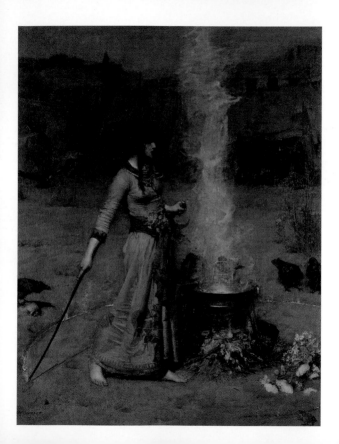

THE MAGIC CIRCLE

CIRCE OFFERING THE CUP
TO ULYSSES
DETAILS

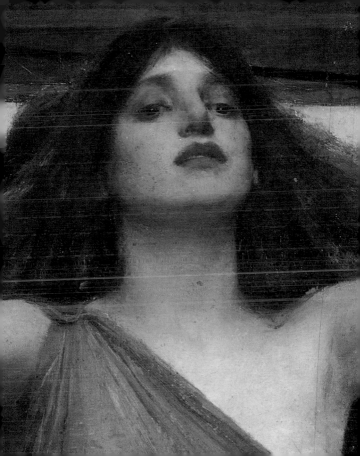

Who knows not Circe,
The daughter of the Sun? whose charmèd cup
Whoever tasted, lost his upright shape,
And downward fell into a groveling swine.

Comus
(John Milton 1608-74)

CIRCE OFFERING THE CUP
TO ULYSSES

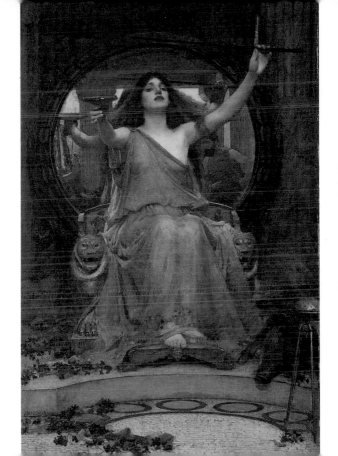

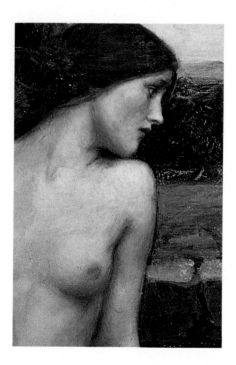

Sweet Echo, sweetest nymph, that liv'st unseen
Within thy airy shell
By slow Meander's margent green,
And in the violet-embroidered vale
Where the lovelorn nightingale
Nightly to thee her sad song mourneth well:
Canst thou not tell me of a gentle pair
That likest thy Narcissus are?

Comus
(John Milton 1608-74)

ECHO AND NARCISSUS
DETAIL AND OVERLEAF

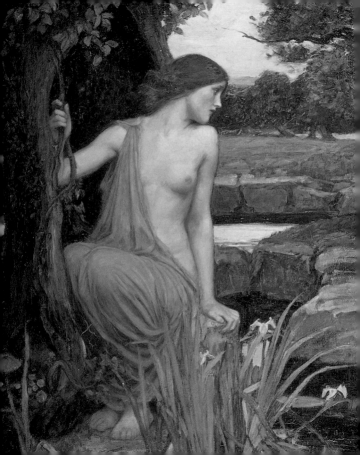

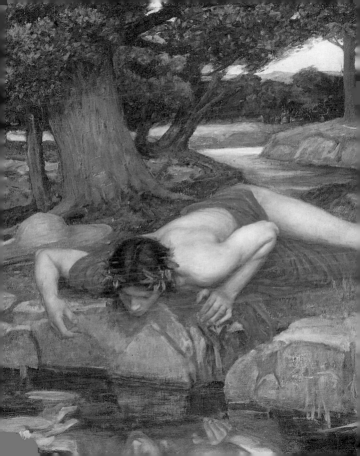

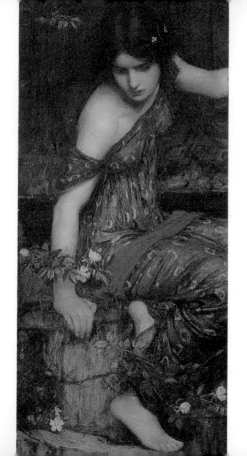

NYMPHS FINDING
THE HEAD OF ORPHEUS
DETAIL

Had ye been there!—for what could that have done?
What could the Muse herself that Orpheus bore,
The Muse herself, for her enchanting son
Whom universal nature did lament,
When by the rout that made the hideous roar
His gory visage down the stream was sent,
Down the swift Hebrus to the Lesbian shore?

Lycidas
(John Milton 1608-74)

**NYMPHS FINDING
THE HEAD OF ORPHEUS**

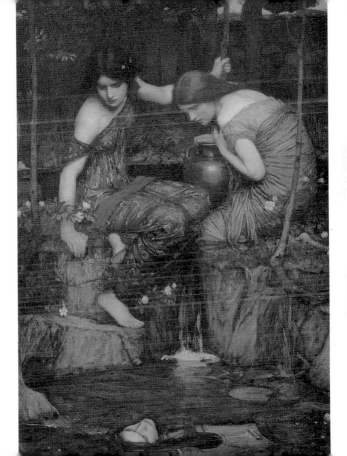

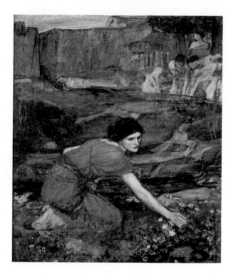

STUDY: MAIDENS PICKING FLOWERS
BY A STREAM

———

FLORA

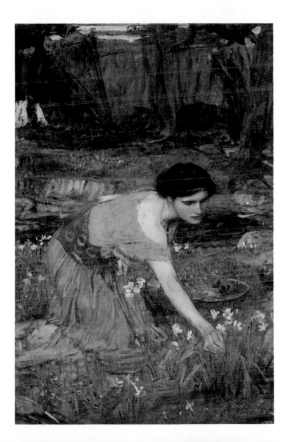

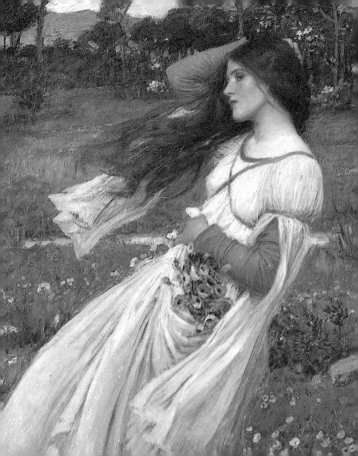

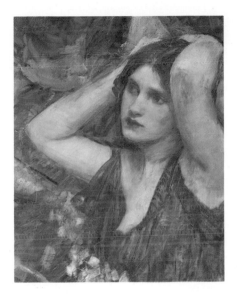

FLORA AND THE ZEPHYRS
DETAIL AND OVERLEAF

WINDFLOWERS
DETAIL

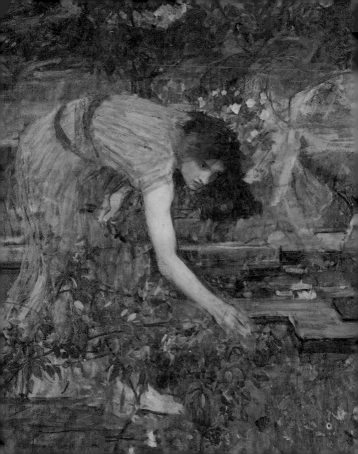

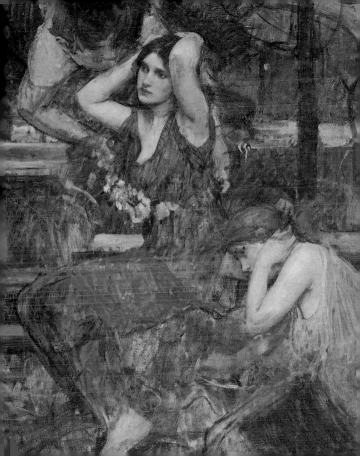

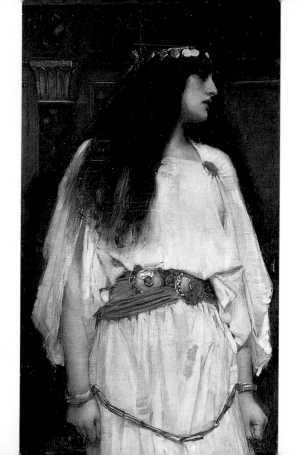

MARIAMNE LEAVING
THE JUDGEMENT SEAT OF HEROD
DETAILS

She's gone, who shared my diadem;
 She sunk, with her my joys entombing;
I swept that flower from Judah's stem,
 Whose leaves for me alone were blooming;
And mine's the guilt, and mine the hell,
 This bosom's desolation dooming;
And I have earn'd those tortures well,
 Which unconsumed are still consuming!

Herod's Lament for Mariamne
(Lord Byron 1788-1824)

MARIAMNE LEAVING
THE JUDGEMENT SEAT OF HEROD

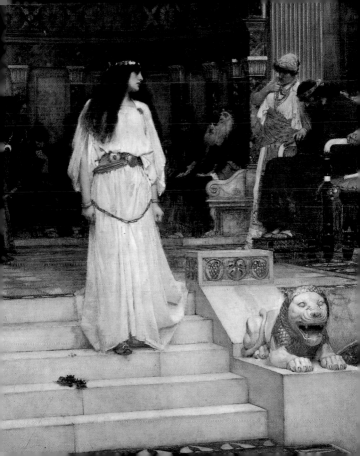

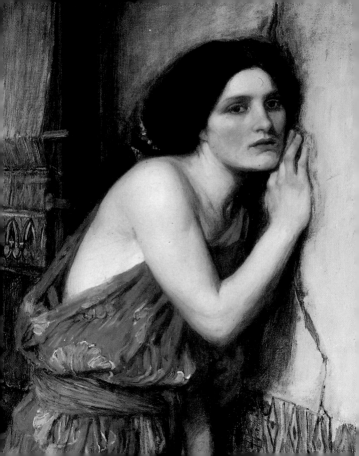

O wall, full often hast thou heard my moans,
For parting my fair Pyramus and me!
My cherry lips have often kiss'd thy stones,
Thy stones with lime and hair knit up in thee.

A Midsummer Night's Dream
Act v, Scene i
(William Shakespeare 1564-1616)

THISBE
DETAIL

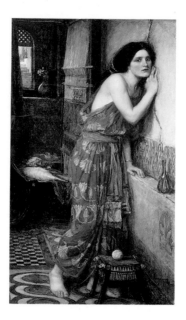

THISBE

—

PANDORA

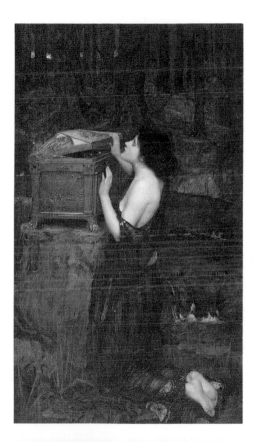

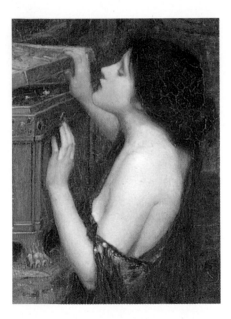

PANDORA
DETAIL

———

PSYCHE OPENING
THE GOLDEN BOX
DETAIL

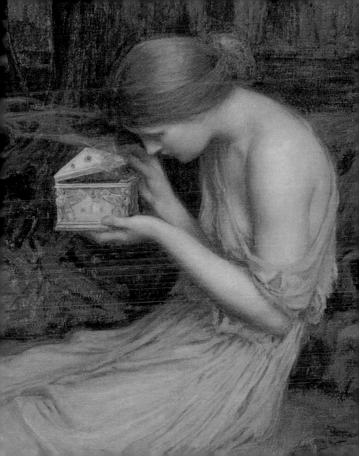

PSYCHE OPENING
THE GOLDEN BOX

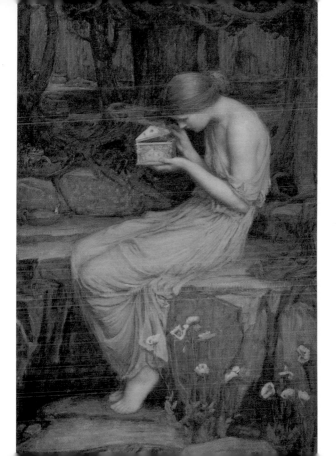

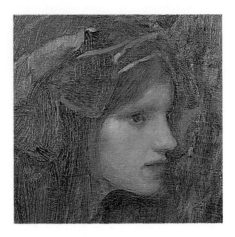

STUDY FOR A NAIAD

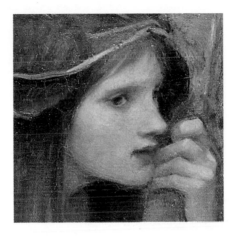

A NAIAD
(HYLAS WITH A NYMPH)
DETAIL AND OVERLEAF

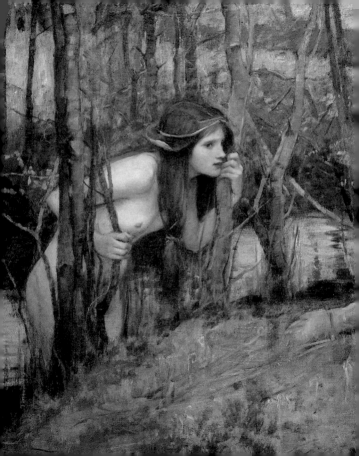

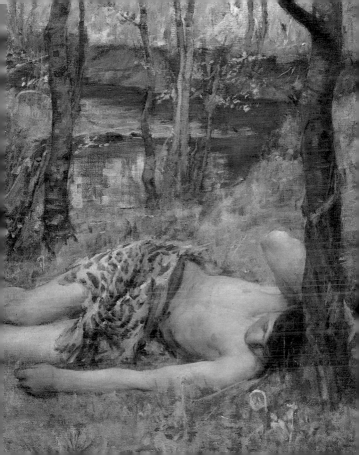

Low on her knees herself she cast,
 Before Our Lady murmur'd she;
Complaining, 'Mother, give me grace
 To help me of my weary load.'
 And on the liquid mirror glow'd
The clear perfection of her face.
 'Is this the form,' she made her moan,
 'That won his praises night and morn?'
 And 'Ah,' she said, 'but I wake alone,
 I sleep forgotten, I wake forlorn.'

Mariana in the South
(Alfred, Lord Tennyson 1809-92)

STUDY FOR MARIANA IN THE SOUTH

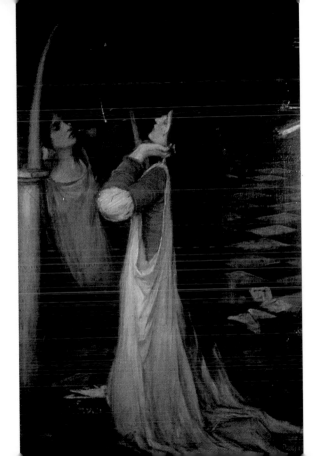

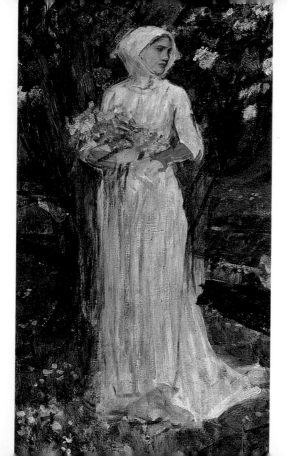

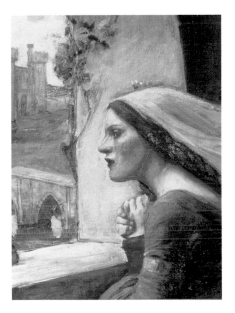

FAIR ROSAMUND
DETAIL

STUDY FOR DANTE AND BEATRICE
DETAIL

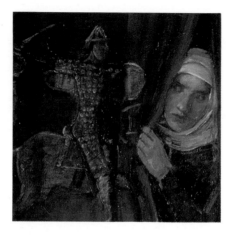

FAIR ROSAMUND

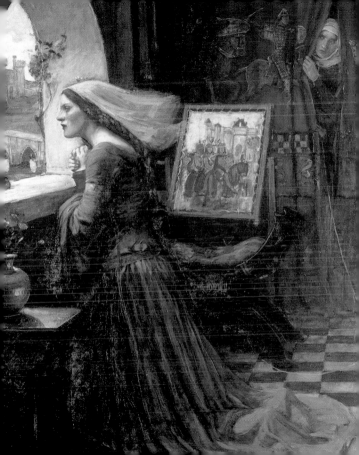

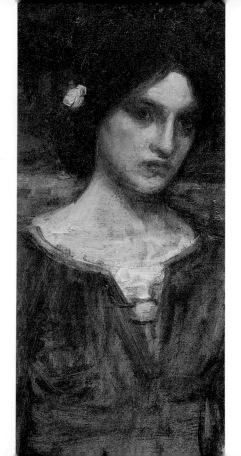

THE LADY CLARE
DETAIL

———

STUDY FOR THE LADY CLARE
DETAIL

She clad herself in a russet gown,
　　She was no longer Lady Clare:
She went by dale, and she went by down,
　　With a single rose in her hair.

The lily-white doe Lord Ronald had brought
　　Leapt up from where she lay,
Dropt her head in the maiden's hand,
　　And follow'd her all the way.

The Lady Clare
(Alfred, Lord Tennyson 1809-92)

THE LADY CLARE

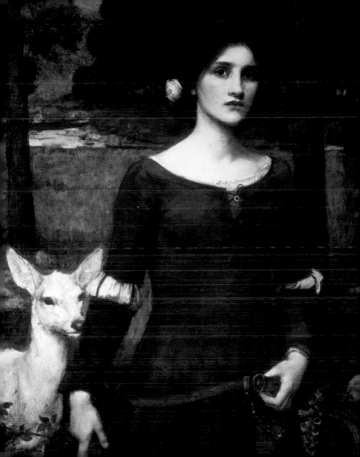

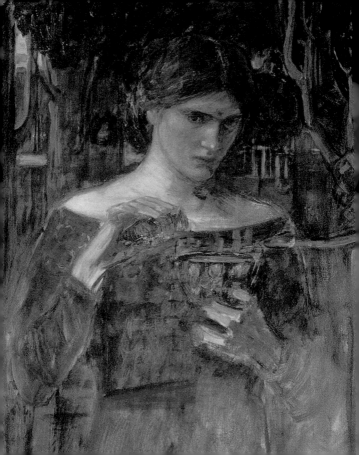

And therin all the famous history
Of *Iason and Medea* was ywrit;
Her mighty charmes, her furious loving fit,
His goody conquest of the golden fleece,
His falsed faith, and love too lightly flit,
The wondred Argo, which in venturous peace.
First through the Euxine seas bore all the flow'r of Greece.

The Faerie Queene
(Edmund Spenser 1552?-99)

STUDY FOR
JASON AND MEDEA

THE SHRINE

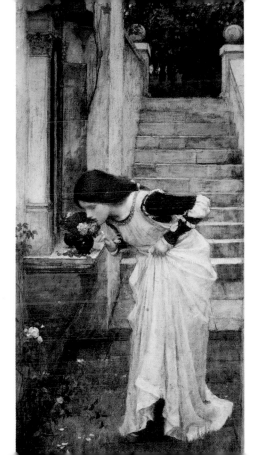

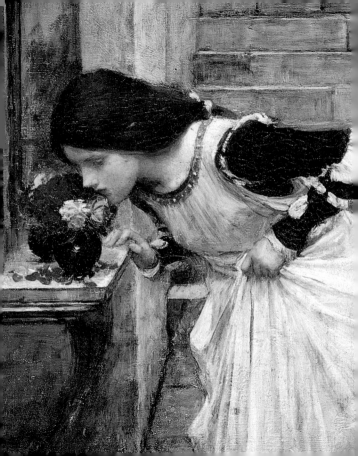

THE ENCHANTED GARDEN
DETAIL AND OVERLEAF

———————

THE SHRINE
DETAIL

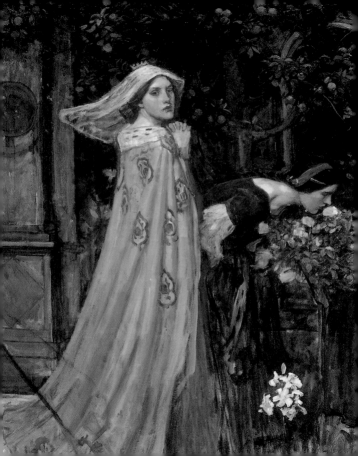

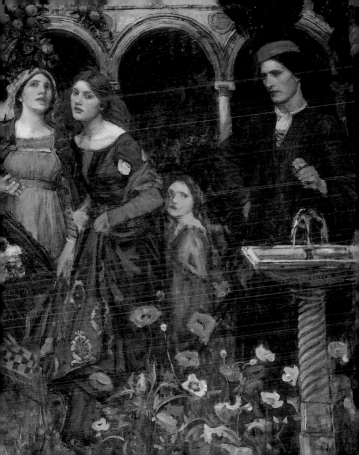

Who would be
A mermaid fair,
Singing alone,
Combing her hair
Under the sea,
In a golden curl
With a comb of pearl,
On a throne?

The Mermaid
(Alfred, Lord Tennyson 1809-92)

A MERMAID

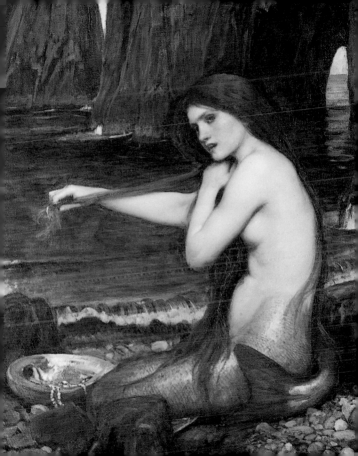

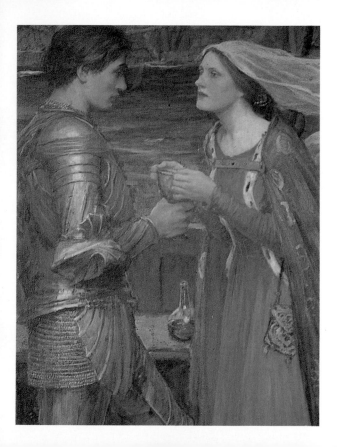

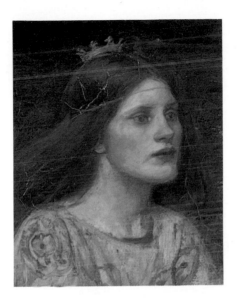

A TALE FROM THE DECAMERON
DETAIL AND OVERLEAF

———

TRISTRAM AND ISOLDE
DETAIL

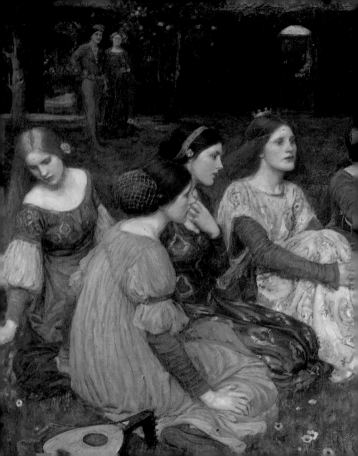

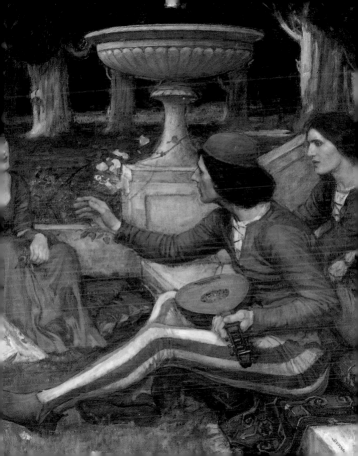

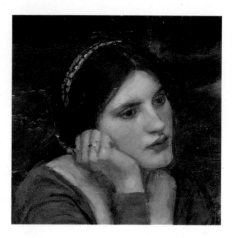

A TALE FROM THE DECAMERON
DETAIL

'LISTENING TO MY SWEET PIPINGS'
DETAIL AND OVERLEAF

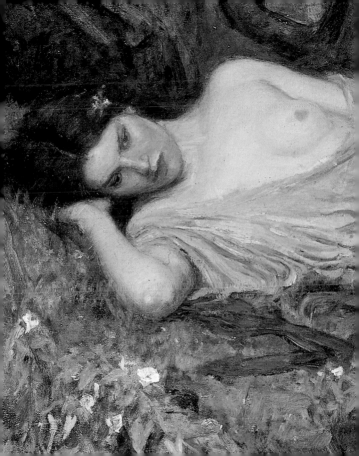

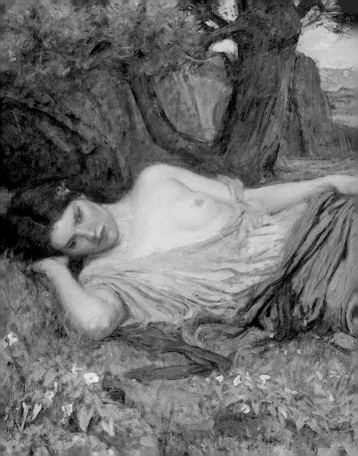

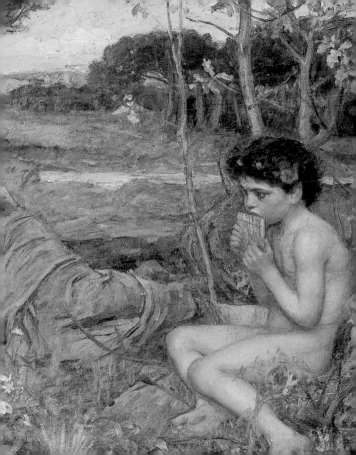

CLASSICAL AND LITERARY SOURCES

ARIADNE

Every year, as payment for the slaughter of Minos' son, the Athenians offered a tribute of youths and maidens to the monstrous Minotaur that dwelt in the Cretan labyrinth. Designed by Dedalus, the labyrinth was built of such complexity that nobody had ever escaped from its confines. Ariadne's father, Minos, the King of Crete, selected Theseus as part of the offering, but on his arrival at the island Ariadne fell in love with him and, loath to see him die, secretly gave him a spool of thread by which he could trace his way from the maze. Theseus slew the Minotaur and fled from Crete, carrying Ariadne away as his wife, but when they arrived at the island of Naxos the Olympic gods shrouded his mind with forgetfulness and he deserted her while she lay asleep.

ADONIS

While hunting, Adonis was mortally wounded by a wild boar and the brightly coloured anemone flowered where his blood was spilled. The youth was so loved by Aphrodite that she beseeched the gods to make him immortal. Persephone awakened Adonis from death but insisted he spent part of the year with her in Hades. His restoration to Aphrodite signifies the birth of spring.

LA BELLE DAME SANS MERCI

The ballad by John Keats tells of a knight-at-arms who is doomed by a chance meeting in the meads with a beautiful lady. Enthralled by her sensual allure, he sets her upon his steed and spends the day bewitched by her enchanting company. He falls into a trance to be haunted by ghostly echoes of the lady's other victims and awakes from his magical slumber to find himself alone on a cold and barren hillside where no birds sing.

CIRCE

On his return from the Trojan War, Ulysses sailed to the fantastic island of Aeaea inhabited by Circe, a beautiful but powerful sorceress. The land was crawling with swine, the metamorphosed forms of men seduced by her potent herbal brews. Ulysses lost his entire crew to her charms, but armed with moly, a herb given to him by Hermes, he was able to withstand her spells and force her to release his men from their bestial shape.

CIRCE INVIDIOSA

The merman Glaucus became enamoured of a dainty nymph called Scylla who came to the waters every day to bathe. Glaucus begged Circe to work her witchcraft upon the nymph to make her return his love, but Circe, intent on the favours of the merman herself, poured one of her poisonous charms into the fountain where her rival swam. No sooner had Scylla stepped into the water than her lower parts were transformed into monstrous barking dogs. Distracted by the hideous metamorphosis and the ugly noise, Scylla threw herself into the sea and was changed into the roaring rocks between Italy and Sicily that bear her name.

THE DANAÏDES

Danaus was blessed with fifty daughters, the Danaïdes, and his twin brother, Aegyptus, was the father of an equal number of sons. A terrible dispute over who should inherit the throne waged between the two men until Aegyptus demanded the betrothal of their offspring to heal the rift by uniting the two kingdoms. Danaus and his daughters resisted this enforced matrimony by fleeing to Argos but Danaus finally granted the marriages, secretly commanding his daughters to murder their husbands on the wedding night. With the exception of Hypermnestra, who suffered her

husband Lynceus to escape, their obedience to his order condemned them to eternal punishment in Hades, where they were set the impossible task of filling a leaky vessel with water.

DANTE AND BEATRICE

Early in his youth, the Florentine, Dante Alighieri (1265-1321), fell deeply in love with a girl who tragically died in 1290. She is celebrated as Beatrice in *La Vita Nuova*, a sequence of poems threaded together by a prose narrative telling their love-story and its spiritual interpretation. Beatrice also appears in his masterpiece, the *Divine Comedy*, as the Poet's guide in Paradise. He meets her at the summit of the purgatorial mountain in a beautiful paradise of music and light.

THE DECAMERON

The Decameron is the work of Giovanni Boccaccio (1313-75), an Italian writer and humanist living at the time of the plague. It tells how seven young ladies, accompanied by three young men, took refuge in the beautiful surroundings of neighbouring villages, to escape the horrors of the Black Death that ravaged Florence in 1348. Ten days elapsed during which time they entertained one another by recounting stories, each person narrating a single tale on each day, so that one hundred tales were told in all.

ECHO AND NARCISSUS

Punished by a goddess for her constant chatter, Echo was confined to repeating the words of others. Enamoured of Narcissus, the son of the river god Cephisus and the nymph Liriope, she tried to win his love using fragments of his own speech but he spurned her attentions. Passing by a stream, the beautiful youth caught

a glimpse of his reflection in a stream and became transfixed by the lovely image. Believing it to be the form of a nymph, he vainly courted the watery mirage and wasted away through unrequited love. He was transformed into the flower that bears his name and Echo pined away until nothing but her voice remained.

FAIR ROSAMUND

A popular legend grew out of the story of Henry II's mistress, Rosamund Clifford who died in 1176. According to the historian Stow, Rosamund was the fair daughter of Walter, Lord Clifford. Henry II jealously guarded her as his concubine in a labyrinth similar to the one constructed by Dedalus. It was rumoured that Queen Eleanor, embittered by her husband's betrayal, found her way into the maze by a thread of silk attached to Rosamund's gown and poisoned her rival.

FLORA AND THE ZEPHYRS

Flora was the Roman goddess of flowering plants. Her annual festival was celebrated with games and indecent farces. She is often alluded to in literature in a sexual context, sporting with the Zephyrs, minor deities of the air named after Zephyrus, the West Wind.

HYLAS AND THE NYMPHS

When the ship of the Argonauts reached the island of Cios, Hylas, the young and handsome companion of Hercules, was sent ashore in search of water. He discovered a fountain, but the nymphs of the place were so enchanted by his beauty that they pulled him to the depths of their watery abode, and in spite of the cries of Hercules which made the shores reverberate with the name Hylas, the young man was never seen again.

JASON AND MEDEA

During the adventure of the Argonauts, Jason put ashore at Colchis where he met Medea, the daughter of Aeetes, and was bewitched by her beauty. Aeetes, the King of Colchis, obstructed Jason's quest for the golden fleece by setting him an impossible task, but Medea, being in love with him, helped him perform it by magic and escaped with him to Greece. Overcome by wrath, Aeetes pursued her and in an effort to delay his advances Medea murdered her brother, strewing his mutilated limbs in her father's path. On their arrival at Iolcos, Medea rejuvenated Jason's father Aeson by boiling him with magic herbs but her evil trickery forced them to flee to Corinth, where Jason deserted her for Glauce. Medea took revenge by slaughtering their children and poisoning her rival.

THE LADY CLARE

Lord Ronald marks his betrothal to Lady Clare, his cousin, by giving her the lover's token of a lily-white doe as a wedding gift. Learning of their intended marriage, Alice the nurse is forced to reveal that Lady Clare is really her own daughter, whom she substituted as a baby when the old Earl's daughter died at her breast. The Lady Clare honourably refuses to marry on a falsehood and putting on peasant's garments boldly confronts her lover with the secret of her lowly birth. He laughs at her tale and marries his 'flower of the earth', making her the true Lady Clare.

LADY OF SHALOTT

Identified by Arthurian romance as Elaine, the Fair Maid of Astolat, the ballad by Alfred, Lord Tennyson portrays the Lady of Shalott as a mysterious maiden who dwells in a tower, alone and unseen, on an island in the river that flows down to Camelot. Bound by a

curse, she passes her days weaving into a fantastic tapestry the sights of Camelot that she glimpses in a mirror that hangs before her. She grows weary of her vicarious life of shadows when the gallant knight, Sir Lancelot, flashes into the crystal mirror. Breaking the thread of her tapestry, she leaves the loom as the curse of love comes upon her. Descending to the water's edge, she finds a moored boat and writes 'The Lady of Shalott' upon its prow, then laying herself down she allows the broad stream to carry her vessel to Camelot, but her life ebbs away before she reaches the shore. The people of Camelot are shocked into silence by the appearance of her strange bier on their shores, but Lancelot is moved by her beauty and asks God to look with grace upon her.

MARIAMNE

According to the historical record left by Flavius Josephus (c 37-95 AD) entitled *The Jewish Antiquities*, Mariamne was the wife of Herod the Great. She fell victim to her husband's sister, Salome, who was jealous of her beauty and concocted a series of charges against her name. She was brought to trial, but Herod was passionately attached to his wife and, unable to tolerate the thought of her death, commuted the sentence. Tragically, his act of forgiveness came too late since Mariamne had already been executed.

MARIANA

The character Mariana in William Shakespeare's *Measure for Measure*, is the jilted lover of Angelo, the acting governor of Vienna. Angelo abuses the powers of government invested in him by the duke, by offering to pardon Isabella's brother, Claudio, who has been sentenced to death for seduction, if she will sacrifice her honour to him. The duke, disguised as a friar,

learns of Angelo's terrible conduct and contrives Claudio's escape. The ruse is for Isabella to consent to attend Angelo's house at midnight, but to send Mariana in her place, thereby foiling Angelo's designs whilst liberating Claudio. Alfred, Lord Tennyson made Mariana the subject of two poems, 'Mariana' and its sequel 'Mariana in the South', dwelling on her abject despair as she waits in the lonely moated grange for her lover to return, while her surroundings decay around her. Her tears fall night and morning and she cannot draw pleasure from anything in heaven or on earth. Tormented by haunting voices from her past, she is overcome by weariness and yearns for death.

MIRANDA

In Shakespeare's play *The Tempest*, Prospero, the Duke of Milan, was usurped by his brother Antonio and cast adrift on the sea with his child, Miranda. Their barely sea-worthy vessel was washed ashore on an island previously populated by Sycorax, a witch, and now inhabited by her son, Caliban, a deformed savage whom Prospero teaches and uses as a slave. Prospero's learning and magic arts release Ariel from his imprisonment in a tree and the spirit agrees to serve the magician out of gratitude. After twelve years on the island, a ship bearing his brother Antonio, together with the King of Naples and his son Ferdinand, is caught in a tempestuous storm whipped up by Prospero and wrecked on the island. Although the passengers are unharmed, they are separated and believe one another to be drowned. Ferdinand and Miranda are magically drawn together by the enchantments of Ariel, fall in love and are married. Ariel, obeying Prospero's orders, torments Antonio and the King of Naples until they repent of their cruelty. The

families are reunited and the ship is magically restored
in order to carry Prospero and the others back to Italy.
The magician's final acts on the island are to renounce
his arts and drown his books and to set Ariel free.
Caliban is left, as before, the island's sole inhabitant.

OPHELIA

In the tragedy of *Hamlet* by William Shakespeare, the
noble King of Denmark is murdered by his brother,
Claudius who then accedes to the throne by marrying,
with improper urgency, the dead man's widow. Hamlet
meets the ghost of his dead father and learning of his
foul murder, swears to take revenge upon his uncle,
feigning madness to veil his murderous thoughts from
other members of the court. Hamlet's philosophical
nature renders him incapable of action, but repelled by
his mother's infidelity he spurns Ophelia, the daughter
of Polonius, whom he had courted but now treats with
contempt. Hamlet stages a play before the King that
re-enacts the murder, as a device for verifying the
ghost's story, and the King betrays himself. Hamlet
vehemently reproaches his mother for her part in the
murder and thinking the King is eavesdropping behind
the curtains draws his sword and slays Polonius in
error. Driven out of her mind by Hamlet's neglect and
the murder of her father, Ophelia wanders down to
a stream, clutching garlands of flowers and slips into
the water where she drowns. Laertes, her brother,
seeks vengeance and the King contrives a fencing
match between Hamlet and Laertes, giving Laertes
a poisoned sword to ensure Hamlet's death. Although
injured, during the battle Hamlet inflicts a mortal
wound upon Laertes and stabs the King before dying,
while Gertrude drinks a cup laced with poison,
intended for her son.

ORPHEUS

In Greek myth, Orpheus, a famous poet and singer, could charm trees, wild beasts and even stones with the skill of his lyre. Orpheus was so devoted to his wife, Eurydice, that when she was killed by the bite of a serpent, he descended to the Underworld to reclaim her. Stirred by the expression of his grief in the exquisite music that he played, the gods consented to restore Eurydice on the condition that he refrained from looking back at her until he had emerged from Hades. At the very end of the tunnel he forgot his promise and glanced back at Eurydice whereupon she was transformed into a wisp of mist and vanished for ever. Orpheus was inconsolable and separated himself from human company, but incurred the wrath of some Thracian women who tore him to pieces in their frustration and lust. His severed head fell into the river Hebrus and was washed out to sea, still chanting the name of Eurydice, and his lyre was placed in the heavens as a constellation.

PANDORA

In myth, Pandora was the first woman ever to be created. At the request of Zeus, she was fashioned from clay by Hephaestus and blessed with every gift the gods could grant. Zeus then endowed her with a box to present to the man who married her, thereby planning to destroy Prometheus' creation of man by giving Pandora to him as a wife. Realizing, however, that Prometheus would be too wise to accept the gift, Zeus conducted her to his less cautious brother, Epimetheus, who married her and opened the box thereby unleashing all the evils and diseases to afflict the world. Only hope lingered at the bottom of the box to console man in his troubles.

PENELOPE

While her husband, Ulysses, was absent fighting in
the Trojan War, Penelope waited faithfully for him in
Ithaca. When he failed to return at the end of the war
she was plagued by persistent suitors and, even though
she remained aloof, the local noblemen could not be
discouraged. Desperate to avoid re-marriage, she con-
ceived the idea of postponing her decision until she
had completed weaving a piece of tapestry intended
as a shroud for Laertes, Ulysses' father. Every night
she unravelled the work she had done during the
day thereby prolonging her labour until the return
of Ulysses finally delivered her from the suitors.

PSYCHE

Psyche, the daughter of a king, incurred the wrath of
Venus who eyed her as a rival. She instructed Cupid,
her son, to infect Psyche's heart with love for an
outcast, but Cupid fell in love with her and visited her
every night in her chamber. Fearing Psyche would be
unable to resist his beauty, he remained invisible
and warned her not to steal a look at him. One night,
overcome with curiosity and goaded by her wicked
sisters, Psyche took a lamp and shone it over Cupid as
he lay asleep. She was so startled by his beauty that she
spilled a drop of hot oil on his shoulder and woke the
god from his slumber. Cupid was filled with anger at
her disobedience and departed at once, leaving Psyche
sad and deeply regretful. She roamed the earth in
search of her lover, facing obstacles thrown in her way
by Venus, until Jupiter took pity on her and made her
immortal so she could be reunited with Cupid.

ST CECILIA

Cecilia lived in Rome around 230 AD. She is famous for taking a lifelong vow of chastity which she kept despite her enforced marriage. She converted her husband to Christianity and both suffered martyrdom. In medieval times, a misreading of her Acts led to her connection with church music and when the Academy of Music was established at Rome in 1584, she was adopted as its patroness. Her saint's day is celebrated on 22 November.

THISBE

Thisbe, a maiden of Babylon, was forbidden by her parents to marry her beloved Pyramus. The two lovers defied their families by exchanging vows through a chink in the wall which divided their houses, and plotted to elope together, fixing upon a white mulberry bush at the tomb of Ninus as the appointed spot. Arriving at the site, Thisbe was surprised by a lioness, fresh from the kill, and, in her haste to escape into a nearby cave, let slip her veil. The lioness mauled the veil, coating it with the blood of her prey. On his arrival, Pyramus discovered the cloth and believing it to be stained with the blood of his love, stabbed himself through the heart. Thisbe, coming out from hiding, found Pyramus' body and overcome with grief, threw herself upon his sword. Their mingled blood seeped into the ground and turned the fruit of the mulberry tree black as a sign of mourning for them.

TRISTRAM AND ISOLDE

In Malory's *Morte D'Arthur*, Tristram was the son of Meliodas, King of Lyonesse and Elizabeth, the sister of King Mark of Cornwall. Tristram became a fine warrior, but was badly wounded in a fierce contest with

Sir Marhaus. He sailed across the waters to Ireland for healing and was restored to health by the King's beauteous daughter, Isolde, with whom he fell in love. Their secret courtship ended when the Queen discovered that Tristram had slain her brother, Sir Marhaus, and he was hounded from the court. Back in Cornwall, his warm praise of Isolde aroused King Mark's envy and, hoping for his destruction, he ordered Tristram to seek the hand of Isolde on his behalf. The King of Ireland granted the request and Isolde, accompanied by her handmaiden, Bragwaine, set sail with Tristram. On board the ship, Tristram and Isolde found a flask containing a magical love potion, given to Bragwaine by Isolde's mother for King Mark, and unaware of its powers, they drank the liquid. Spellbound by the potion, Tristram and Isolde continued their romance back in Cornwall despite her marriage to Mark, but one day Mark discovered the lovers together and murdered Tristram in a jealous rage.

ULYSSES AND THE SIRENS

After the Trojan War, Ulysses set sail for Ithaca, but encountered many obstacles on his homeward journey. Having successfully navigated between the perilous rocks of Scylla and the churning waters of Charybdis, Ulysses steered his ship toward an island inhabited by the Sirens. The meadows were littered with the decaying corpses of unwary mariners, lured onto the island by the Sirens' song, but forewarned by Circe of their devilish charms, Ulysses strapped himself to the mast and, shutting his ears to their hypnotic song, passed by safely.

PHOTOGRAPHIC ACKNOWLEDGEMENTS

City of Aberdeen Art Gallery & Museums
Art Gallery of South Australia
BAL/Bonhams, London
BAL/Christie's, London
Christies's Images, London
BAL/Falmouth Art Gallery, Cornwall
Fine Art Photographs, London
BAL/Forbes Magazine Collection, New York
Hammersmith & Fulham Archives,
 Local History Collection, London
Harris Museum & Art Gallery, Preston
BAL/Hessisches Landesmuseum, Darmstadt
City Art Gallery, Leeds
BAL/The Maas Gallery, London
BAL/Manchester City Art Galleries
Board of Trustees of the National Museums & Galleries
 on Merseyside, Lady Lever Art Gallery, Port Sunlight
BAL/Roy Miles Gallery, 29 Bruton Street, London W1
Peter Nahum at the Leicester Galleries, London
BAL/Oldham Art Gallery, Lancashire
Art Gallery of Ontario, Toronto.
 Gift of Mrs Phillip B. Jackson, 1971
City of Portsmouth Art Gallery/Photo Robert Chapman
Pre-Raphaelite Inc by courtesy of Julian Hartnoll
Royal Academy of Arts, London
Sotheby's, London
Tate Gallery, London
BAL/Towneley Hall Art Gallery, Burnley
National Gallery of Victoria, Melbourne.
 Purchased with the assistance of a Government Grant, 1891
BAL/Walker Art Gallery, Liverpool
BAL/Whitford and Hughes, London
BAL/Christopher Wood Gallery, London

BAL = The Bridgeman Art Library, London

LIST OF PLATES

Ariadne
1898
Oil on canvas
91 x 151 cm
Private collection

Awakening of Adonis, The
1899
Oil on canvas
95.9 x 188 cm
Private collection

Belle Dame Sans Merci, La
1893
Oil on canvas
112 x 81 cm
Darmstadt,
Hessisches Landesmuseum

Bouquet, The
c1908
Oil on canvas
57 x 39.5 cm
Falmouth Art Gallery

Camellias
c1910
Oil on canvas
34 x 25.5 cm
Private collection

Circe Invidiosa
1892
Oil on canvas
180.7 x 87.4 cm
Adelaide, Art Gallery of
South Australia

*Circe offering the Cup
to Ulysses*
1891
Oil on canvas
149 x 92 cm
Oldham Art Gallery

Danaïdes
1904
Oil on canvas
154.3 x 111.1 cm
Private collection

Danaïdes, The
1906
Oil on canvas
161.3 x 123.2 cm
Aberdeen
Art Gallery and Museum

Dante and Beatrice, Study for
c1915
Oil on canvas
47 x 58.5 cm
Private collection

Destiny
1900
Oil on canvas
68.5 x 55 cm
Burnley, Towneley Hall
Art Gallery

Echo and Narcissus
1903
Oil on canvas
109.2 x 252.7 cm
Liverpool, Walker
Art Gallery

Enchanted Garden, The
1916
Oil on canvas
112 x 161 cm
Port Sunlight,
Lady Lever Art Gallery

Fair Rosamund
1917
Oil on canvas
96.6 x 72 cm
Private collection

Flora
Oil on canvas
102.2 x 68.5 cm
Private collection

Flora and the Zephyrs
c1898
Oil on canvas
104.1 x 203.8 cm
Private collection

Hamadryad, A
c1895
Oil on canvas
160 x 61 cm
City of Plymouth
Art Gallery

Hylas and the Nymphs
1896
Oil on canvas
98.2 x 163.3 cm
Manchester City
Art Gallery

'I am half-sick of shadows,'
said the Lady of Shalott
1916
Oil on canvas
100 x 74 cm
Toronto,
Art Gallery of Ontario

Jason and Medea, Study for
c1907
Oil on canvas
91.5 x 61 cm
Private collection

Lady Clare, Study for The
c1884
Oil on canvas
106.7 x 81.3 cm
Private collection

Lady Clare, The
1900
Oil on canvas
76.2 x 61 cm
London, The Maas Gallery

Lady of Shalott, Study for The
c1894
Oil on canvas
120.5 x 68.3 cm
Falmouth Art Gallery

Lady of Shalott, The
1888
Oil on canvas
153 x 200 cm
London, Tate Gallery

Lady of Shalott, The
1894
Oil on canvas
142 x 86 cm
Leeds, City Art Gallery

'Listening to my
Sweet Pipings'
1911
Oil on canvas
58.4 x 104.1 cm
Private collection

Magic Circle, The
1886
Oil on canvas
183 x 127 cm
London,
Tate Gallery

Mariamne leaving the
Judgement Seat of Herod
1887
Oil on canvas
259 x 180 cm
New York,
Forbes Magazine Collection

Mariana in the South,
Study for
c1897
Oil on canvas
131 x 81 cm
London, Hammersmith &
Fulham Archives

Mermaid, A
1901
Oil on canvas
98 x 67 cm
London,
Royal Academy of Arts

Miranda – The Tempest
1916
Oil on canvas
98 x 136 cm
Private collection

Naiad, A (Hylas with
a Nymph)
1893
Oil on canvas
Private collection

Naiad, Study for A
c1893
Oil on canvas
29.2 x 24.1 cm
Private collection

Nymphs finding the head
of Orpheus
1900
Oil on canvas
149 x 99 cm
Private collection

Nymphs finding the head of
Orpheus, Study for
c1900
Oil on canvas
97 x 104 cm
Private collection

Ophelia
1894
Oil on canvas
124.5 x 73.5 cm
Private collection

Ophelia
1910
Oil on canvas
102 x 61 cm
Private collection

Pandora
1896
Oil on canvas
152 x 91 cm
Private collection

Penelope and the Suitors
1912
Oil on canvas
131 x 191 cm
Aberdeen
Art Gallery & Museum

*Portrait of a Lady in
a green dress*
Oil on canvas
Private collection

*Psyche Entering Cupid's
Garden*
1904
Oil on canvas
109 x 71 cm
Preston, Harris Museum
& Art Gallery

*Psyche Opening
the Golden Box*
1903
Oil on canvas
117 x 74 cm
Private collection

Rose Bower, The
c1910
Oil on canvas
54 x 61.5 cm
Private collection

Shrine, The
1895
Oil on canvas
88 x 42 cm
London,
Christopher Wood Gallery

Siren, The
c1900
Oil on canvas
81 x 53 cm
Private collection

Sorceress, Study for The
c1911
Oil sketch
58.4 x 48.3 cm
Private collection

Sorceress, The
c1911
Oil on canvas
74 x 109 cm
Private collection

St Cecilia
1895
Oil on canvas
117 x 196 cm
Private collection

*Study: Maidens Picking
Flowers by a Stream*
c1911
Oil on canvas
94 x 80 cm
Private collection

Study: Necklace, The
c1909
Oil on canvas
95.2 x 64.7 cm
Private collection

Tale from the Decameron, A
1916
Oil on canvas
102 x 159 cm
Port Sunlight,
Lady Lever Art Gallery

Thisbe
1909
Oil on canvas
97 x 60 cm
Private collection

Tristram and Isolde
c1916
Oil on canvas
106 x 77.5 cm
Courtesy Whitford &
Hughes

Ulysses and the Sirens
1891
Oil on canvas
100 x 201.7 cm
Melbourne,
National Gallery of Victoria

Vanity
c1910
Oil on panel
37 x 27 cm
Private collection

Windflowers
1903
Oil on canvas
114 x 79 cm
Private collection

Phaidon Press Limited
2 Kensington Square
London W8 5EZ

First Published 1994
©1994 Phaidon Press Limited
ISBN 0 7148 3264 2

A CIP catalogue record for this book
is available from the British Library

Printed in Hong Kong